BESS
Takes A Ride

Walter C. Kilgus
Illustrated by Craig Howarth

Copyright © 2018 by Walter C. Kilgus. 577044
Library of Congress Control Number: 2007907883

ISBN: Softcover 978-1-4257-8807-0
 Hardcover 978-1-4257-8821-6
 EBook 978-1-4771-7555-2

Print information available on the last page

Rev. date: 11/09/2018

To order additional copies of this book, contact:
Xlibris
1-888-795-4274
www.Xlibris.com
Orders@Xlibris.com

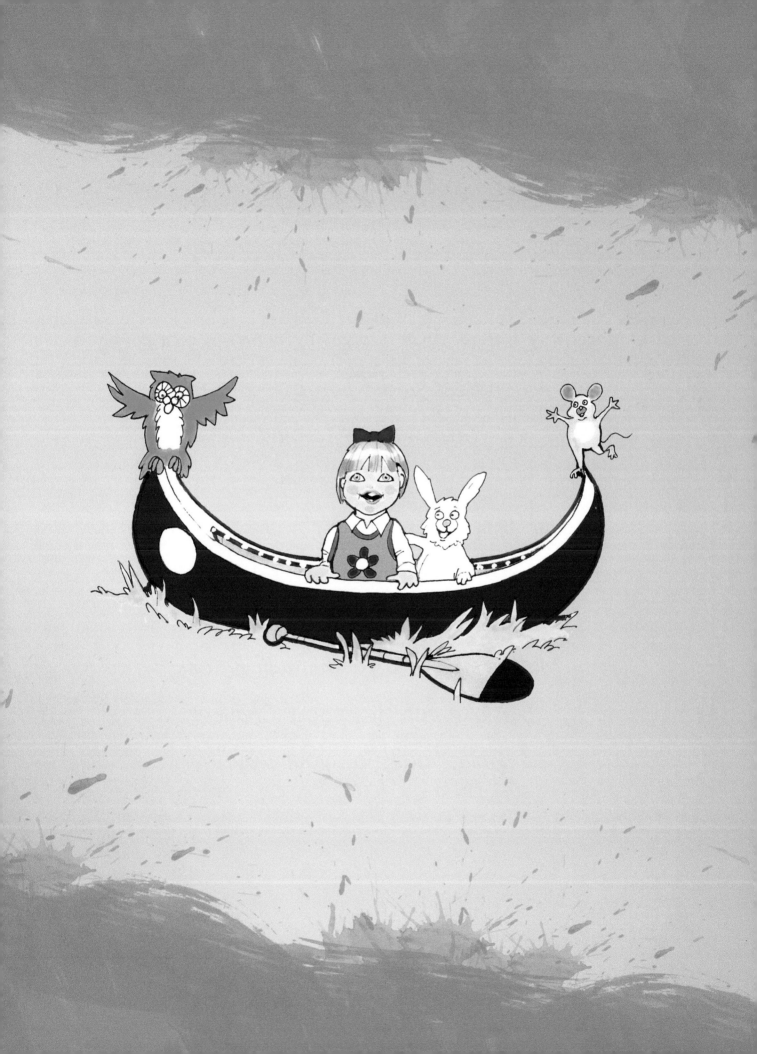

Bess and her mother were at Grandma's one day
when Bess said, "I'm going to the
Great Woods to play."

Her sister Emma wasn't there that day
when Bess went out to the Great Woods to play.

Mother said, "Bess, that will be okay,
but take our sheepdog, Chaucer,
while you're on your way."

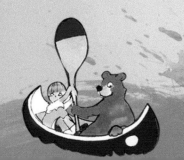

As Bess went walking in the
Great Woods that day,
she passed by the pond where
the frogs all said, "G-day."

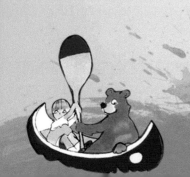

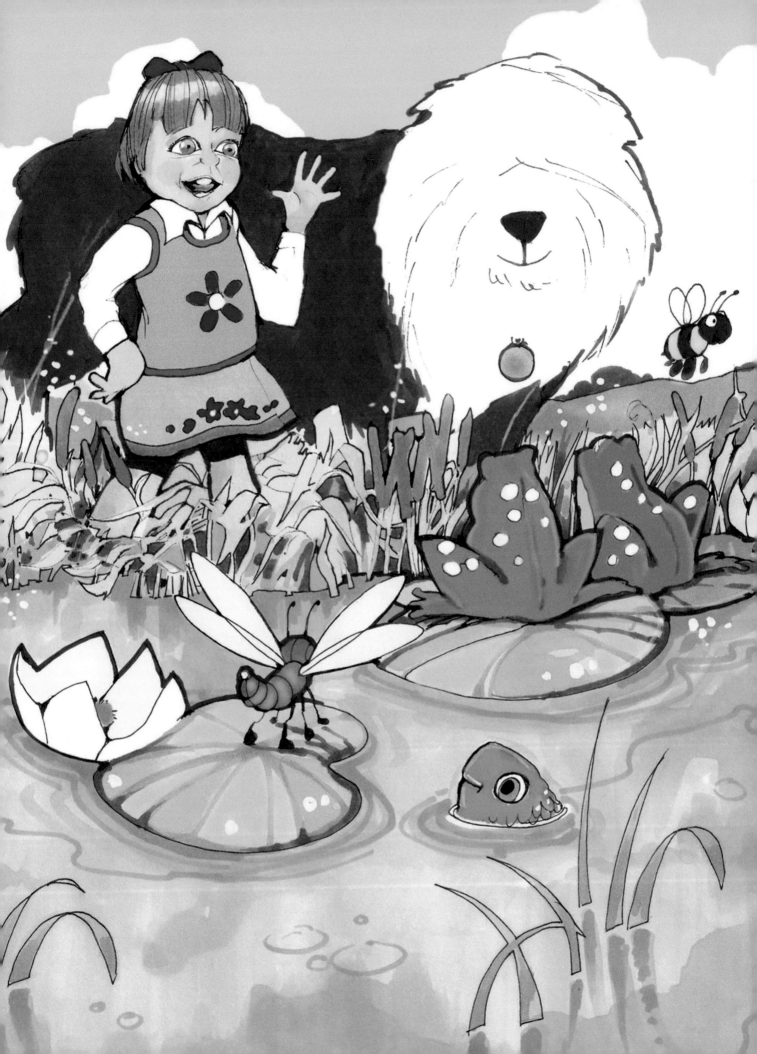

Soon the Rock Creek came into view,
and there on the shore was
Grandpa's old canoe.

Bess thought, "I know just what I'll do.
I'll take a ride in Grandpa's
old canoe."

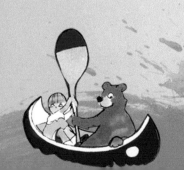

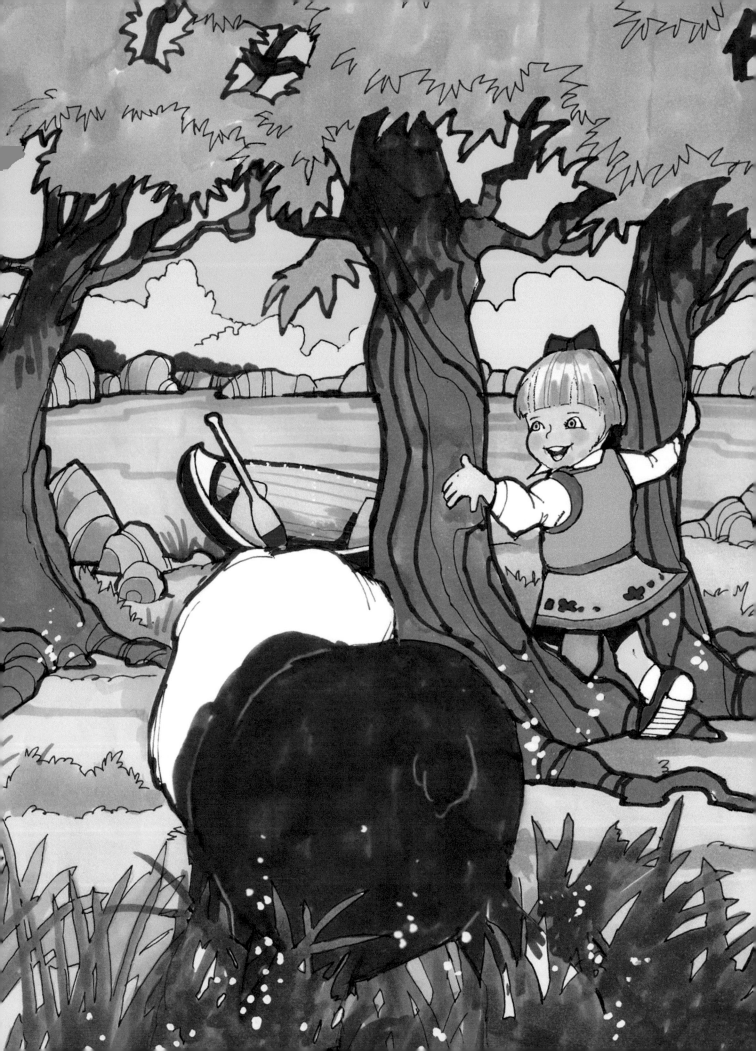

Olivia Owl, in her tree, said
"Whoo! Whoo! Whoo!
Who, little Bess, is going with you?"

The other animals were watching, too,
as Bess got into Grandpa's old canoe.

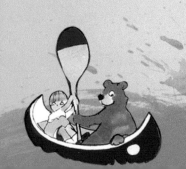

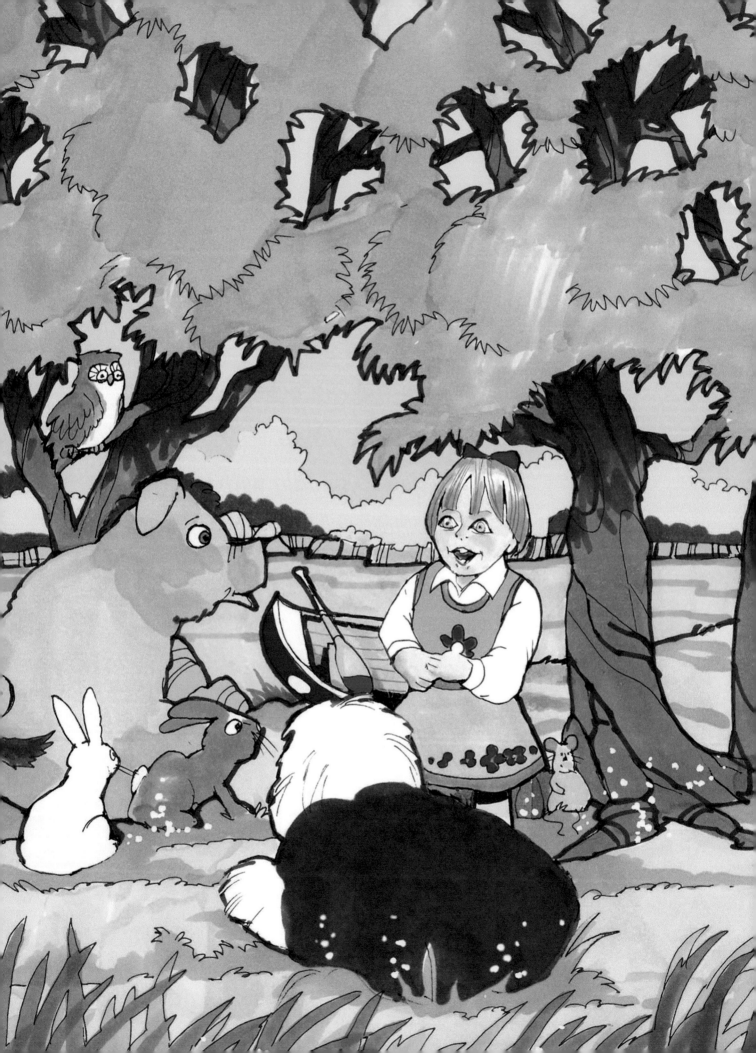

She pushed the red canoe off
from the shore
and began to paddle with
Grandpa's old oar.

She floated down the creek that
was calm and wide,
and the animals all ran along beside.

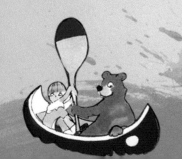

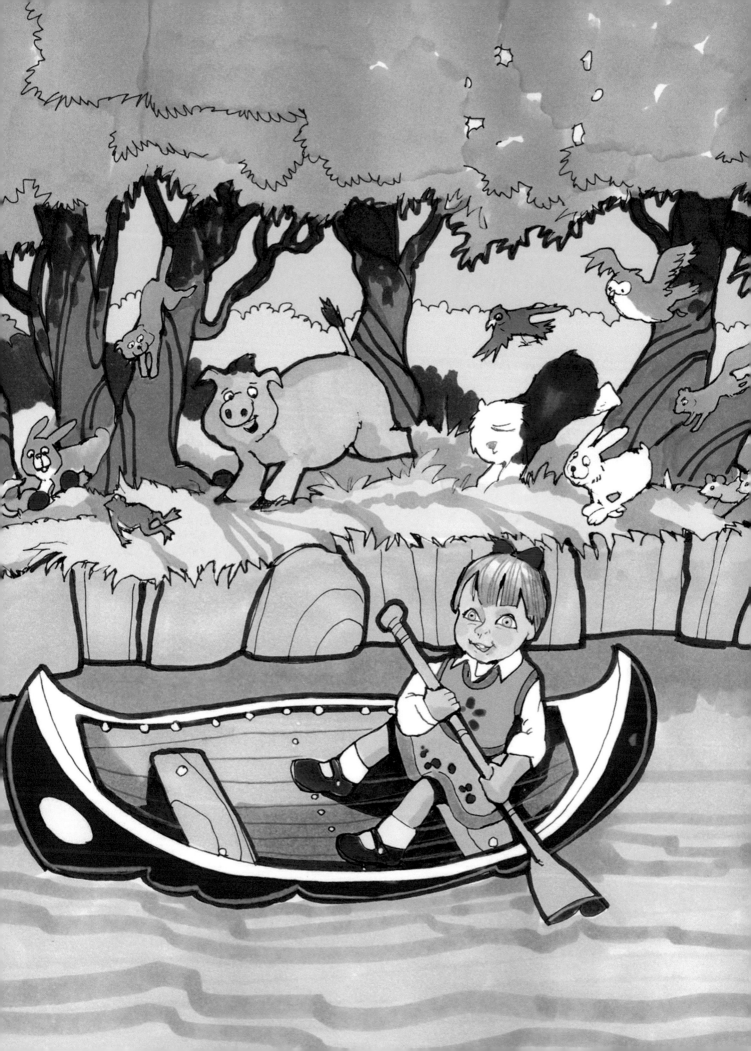

Up ahead, on a rock in the middle of the creek,
Bess saw Beulah Bear who had started to weep.
Beulah was crying, "Boo, Hoo! Hoo!"
and Bess called, "Beulah, what's wrong with you?"

"I tried to swim across," little Beulah Bear cried,
"but I'm afraid the creek is much too wide,
and I can't make it to the other side."

Bess said, "Beulah, I'm going for a ride,
and I'll take you over to the other side."

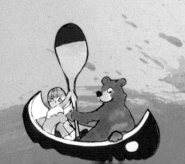

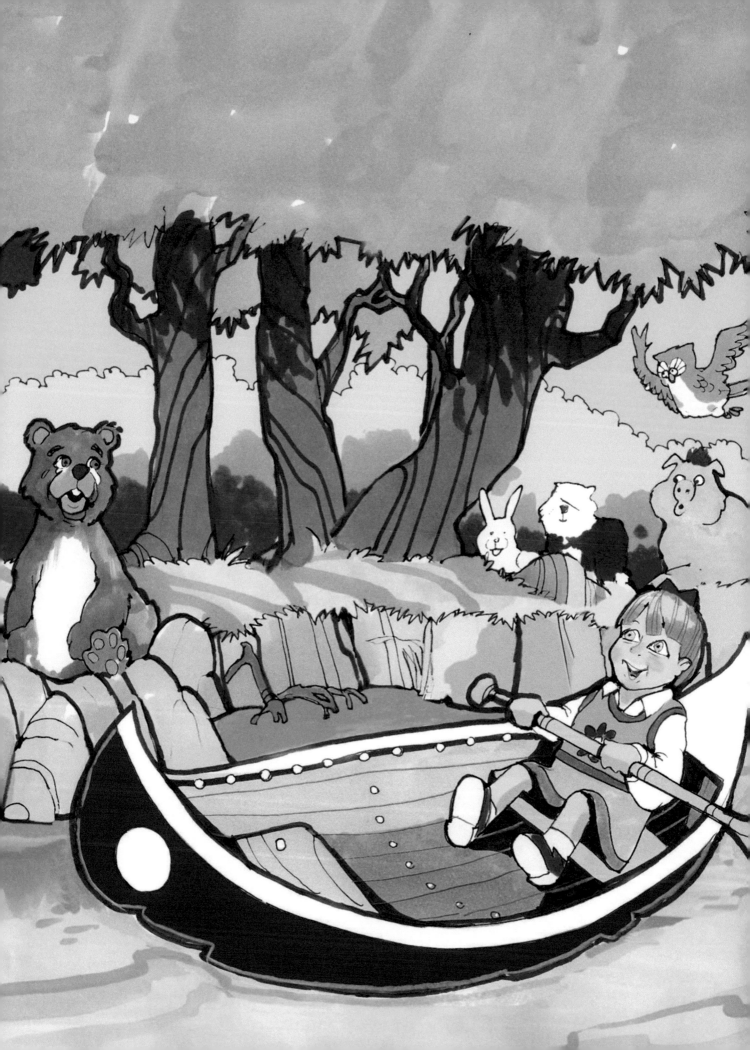

So Beulah hopped in, and now there
were two floating
down the Rock Creek in Grandpa's old canoe.

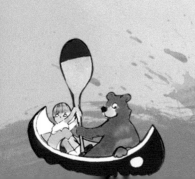

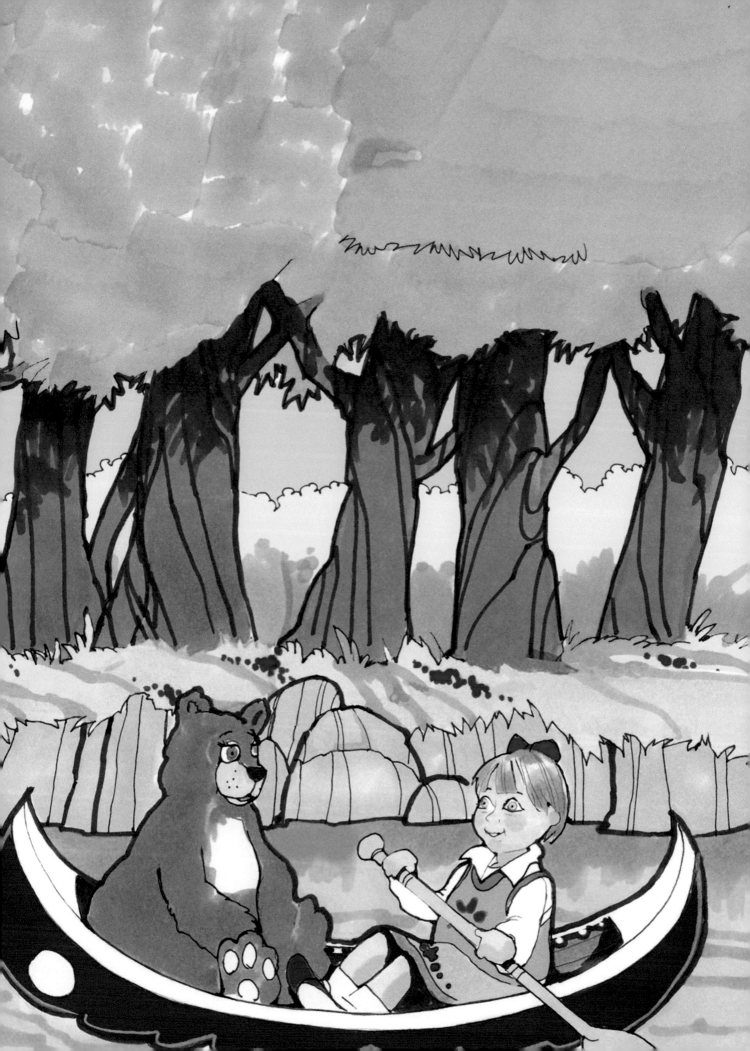

Suddenly the creek wasn't calm anymore.

Bess could hear the waterfall's roar,
and the little canoe couldn't reach the shore.

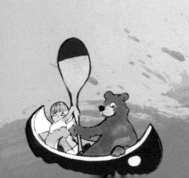

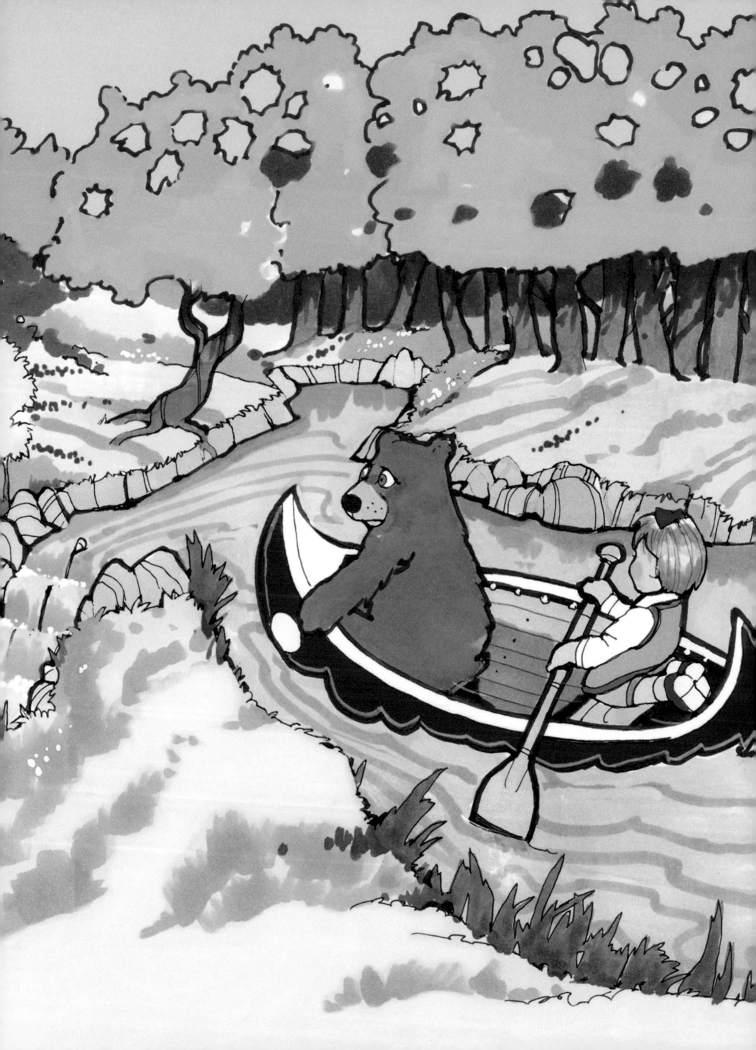

Around the bend not far away,
Bess's Daddy and Uncle Adam
were fishing that day.

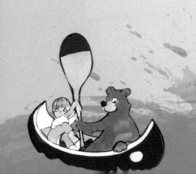

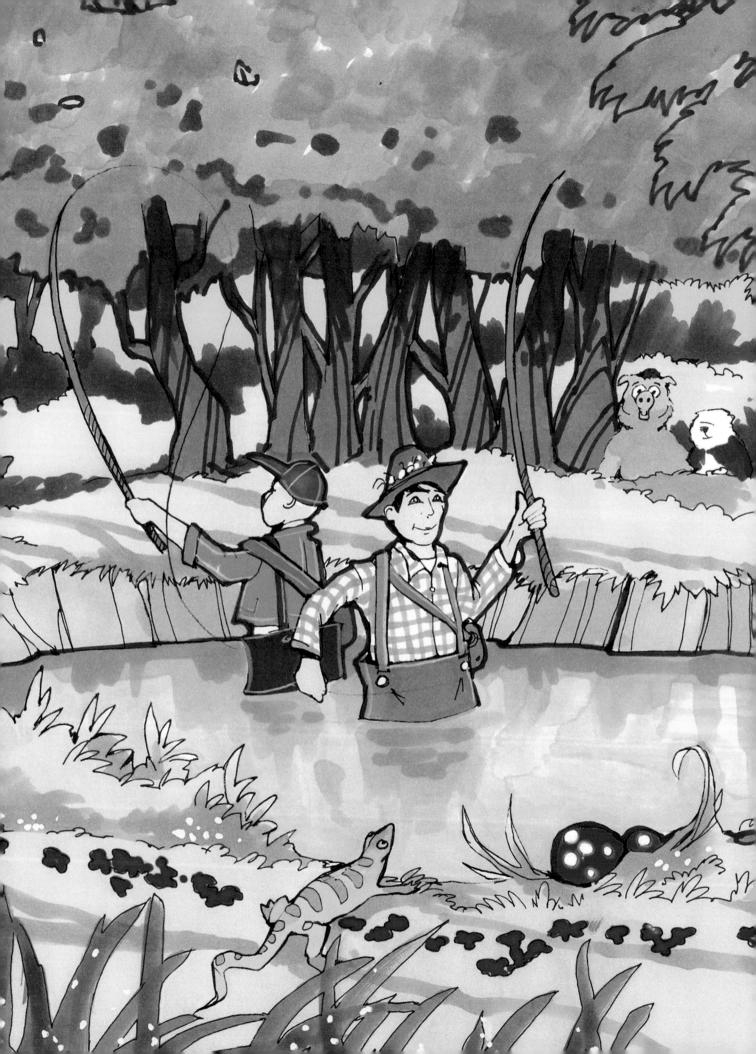

They heard lots of noise
and the animals' cries and down the
creek came a big surprise.

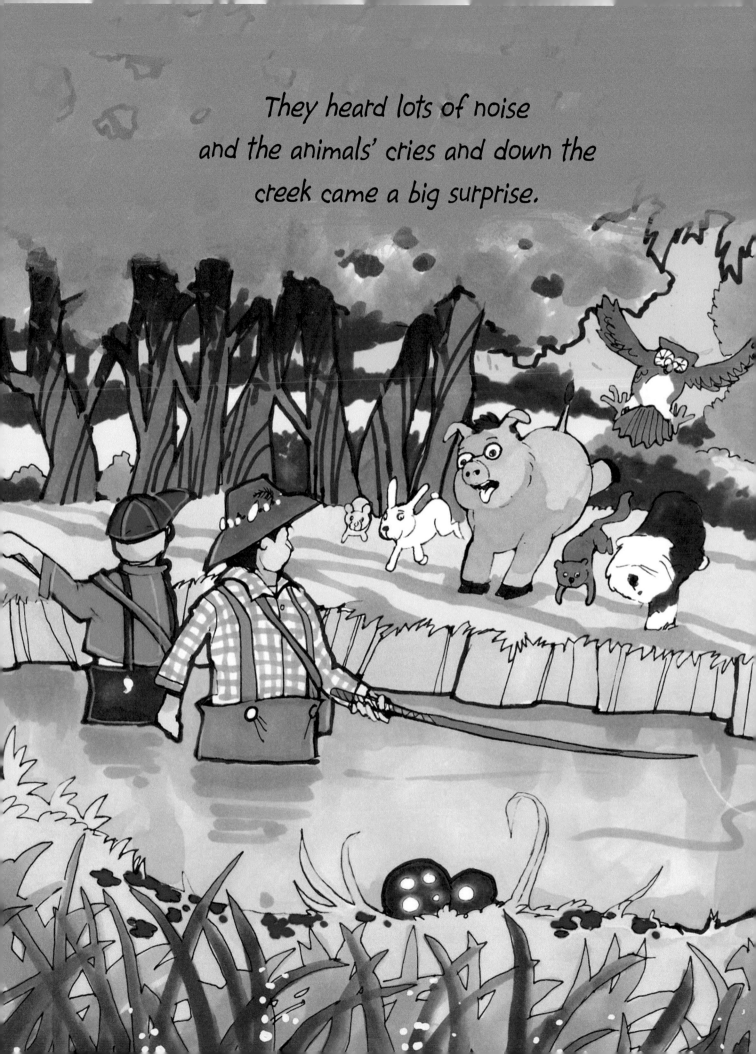

Bess and Beulah Bear in Grandpa's old
canoe and the animals all shouting,
"What shall we do?"

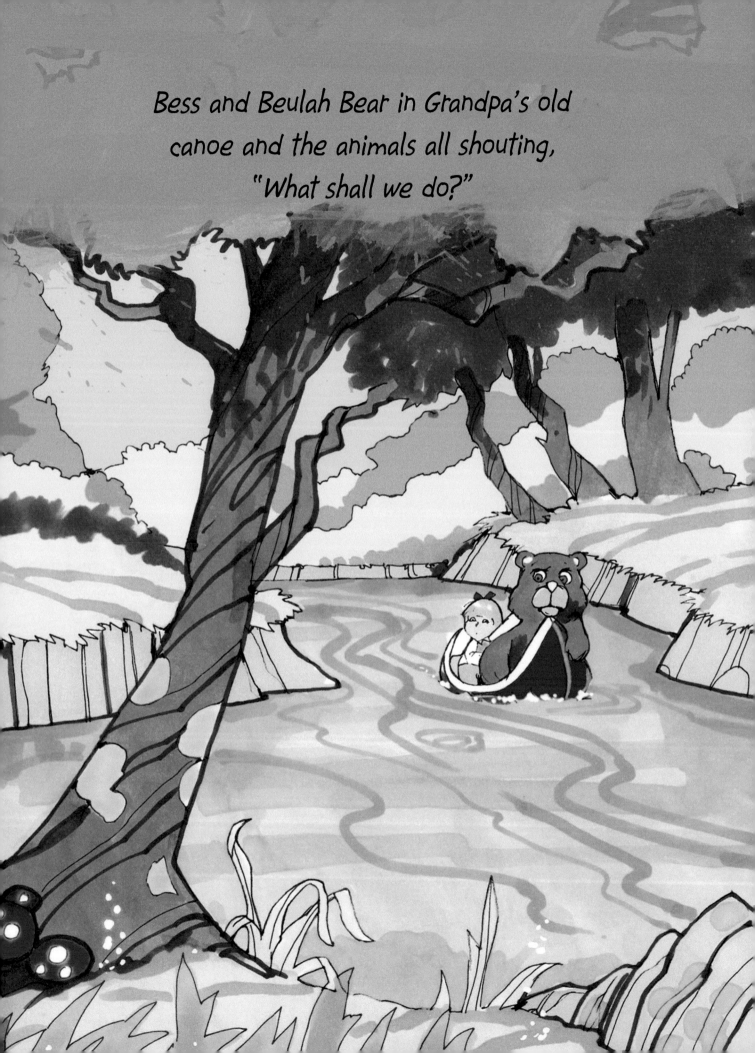

Daddy said to Uncle Adam,
"Take hold of that tree and I'll lean way out
while you hold on to me."

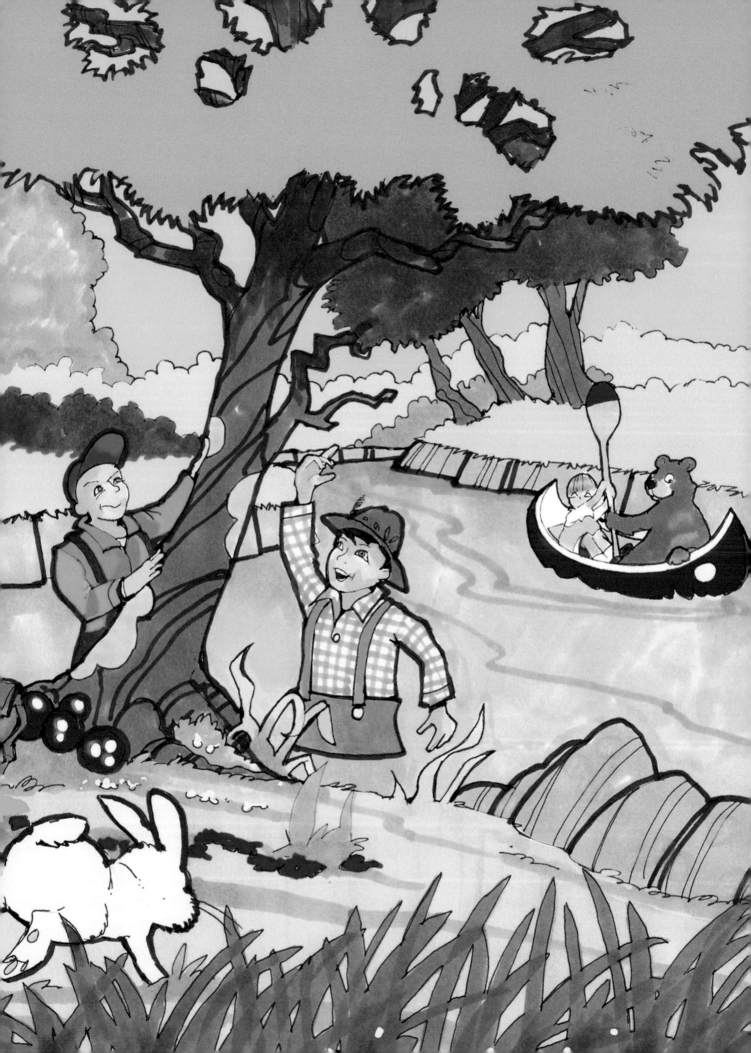

As the canoe went by, Bess held out the oar
and Daddy grabbed hold and pulled them
safely to the shore.

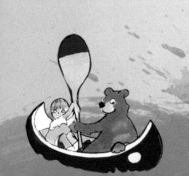

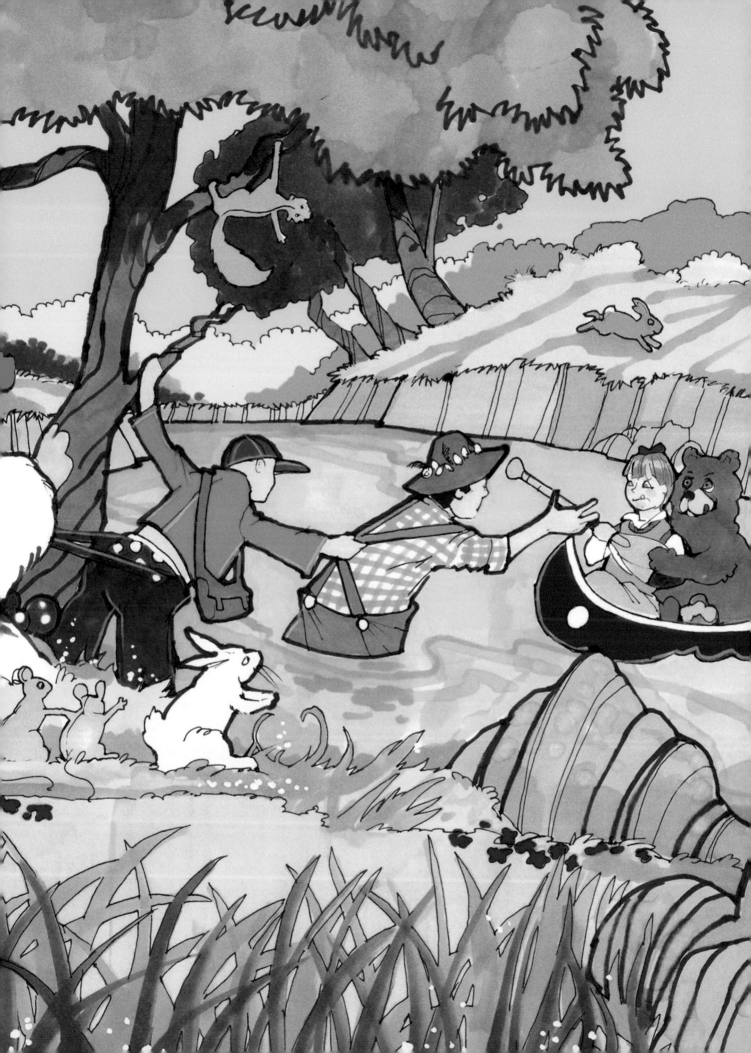

The animals cheered as never before,
and Willi the Wild Boar roared
his great roar.

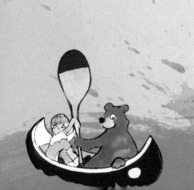

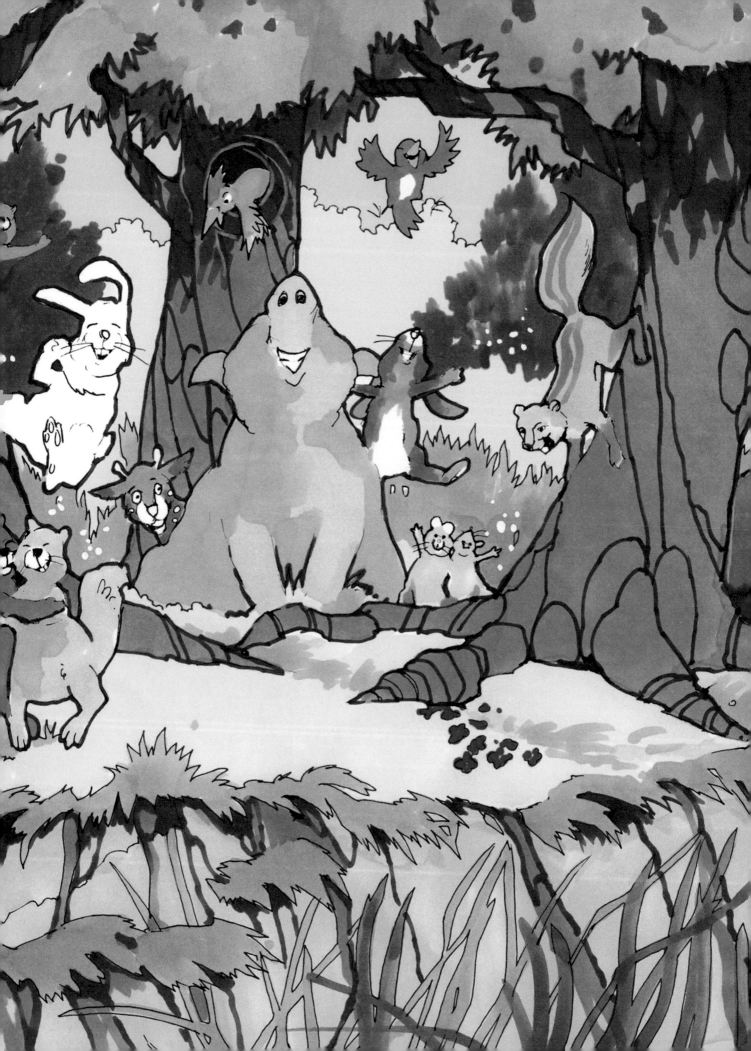

Beulah Bear said, "Bess, I sure thank you.

I was stuck on that rock and didn't know what to do,
and I'd still be there if it weren't for you."

Bess said, "Beulah, I'm glad you're ok. We had quite a
ride in the canoe today."

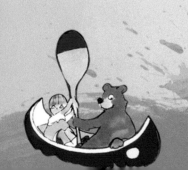

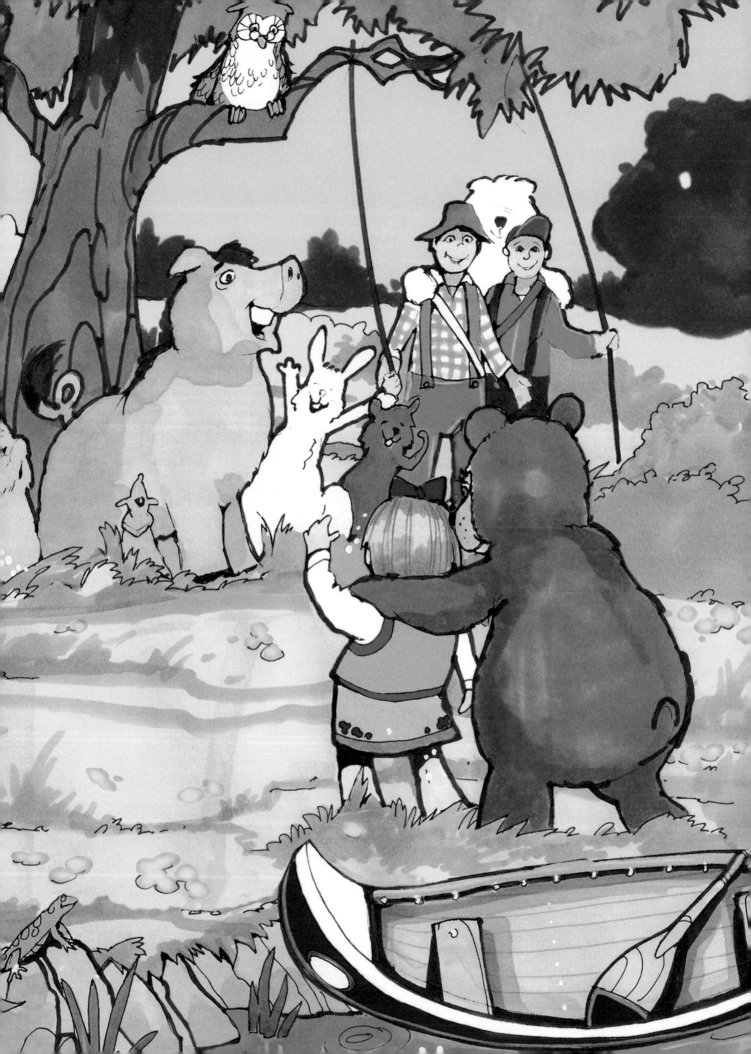

And that's what happened one
fine spring day,
when Bess went out to the Great
Woods to play.

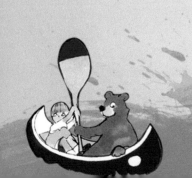

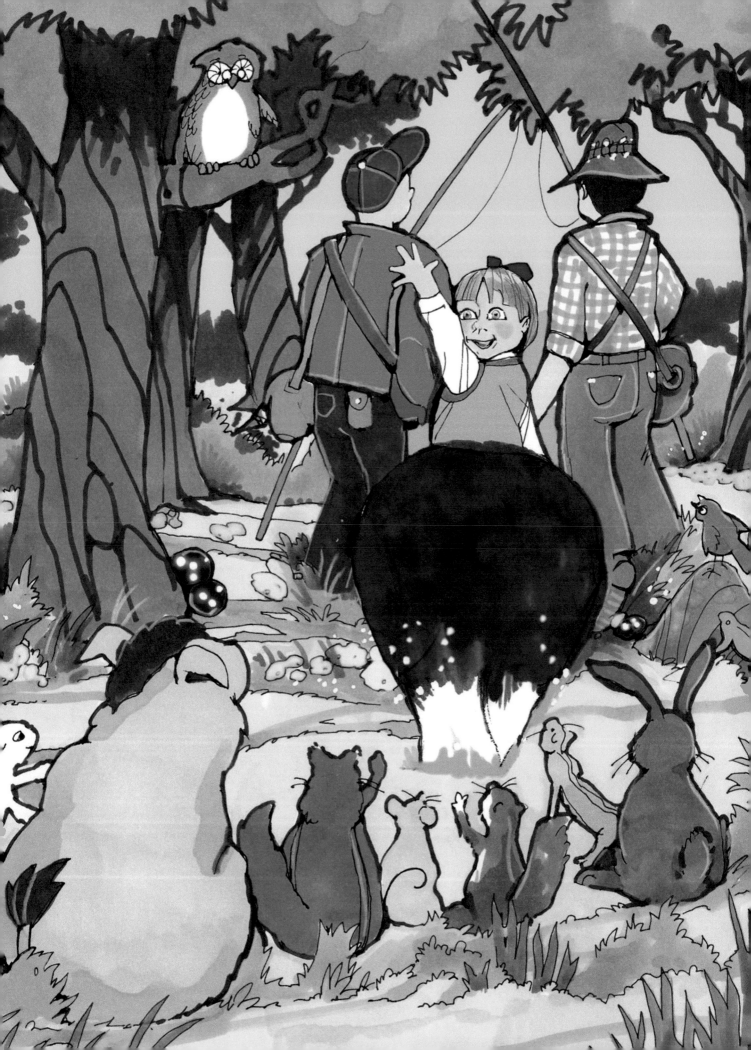

THE END

Printed in the United States
By Bookmasters